TRÈS CHIC!

THE GOLDEN AGE OF FRENCH COOL
IN SOUND & PICTURES

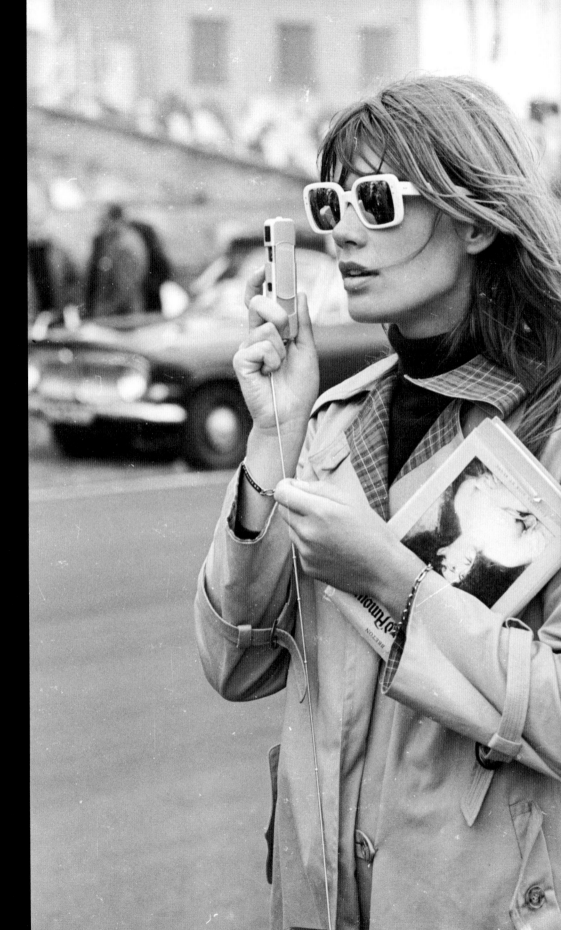

Françoise Hardy on the 'Grand Prix' movie set. Brands
Hatch, England, July 1966

Françoise Hardy photographiée sur la scène du film
'Grand Prix'. Brands Hatch, en Angleterre, Juillet 1966

Françoise Hardy auf dem 'Grand Prix' Film-Set. Brands
Hatch, England, Juli 1966

Françoise Hardy sul set del film 'Grand Prix'. Brands
Hatch, in Inghilterra, luglio 1966

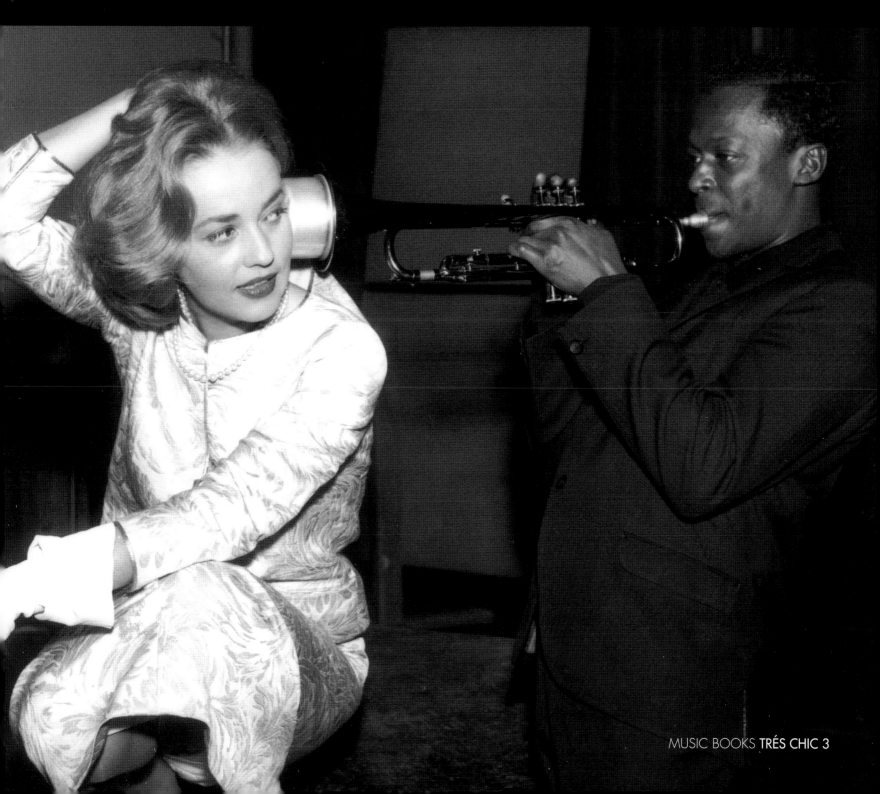

MUSIC BOOKS **TRÉS CHIC 3**

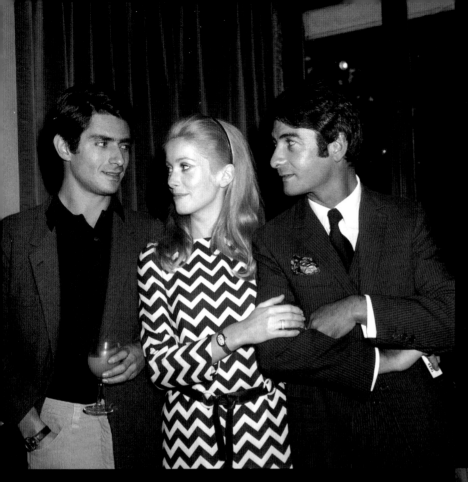

Jean-Claude Brialy, Catherine Deneuve and Sami Frey. Paris 1967

Jean-Claude Brialy, Catherine Deneuve et Sami Frey. Paris 1967

Jean-Claude Brialy, Catherine Deneuve und Sami Frey. Paris 1967

Jean-Claude Brialy, Catherine Deneuve e Sami Frey. Paris 1967

Françoise Hardy at the Olympia. November 1963

Françoise Hardy à l'Olympia. Novembre 1963

Françoise Hardy, Olympia, November 1963

Françoise Hardy all'Olympia. Novembre 1963

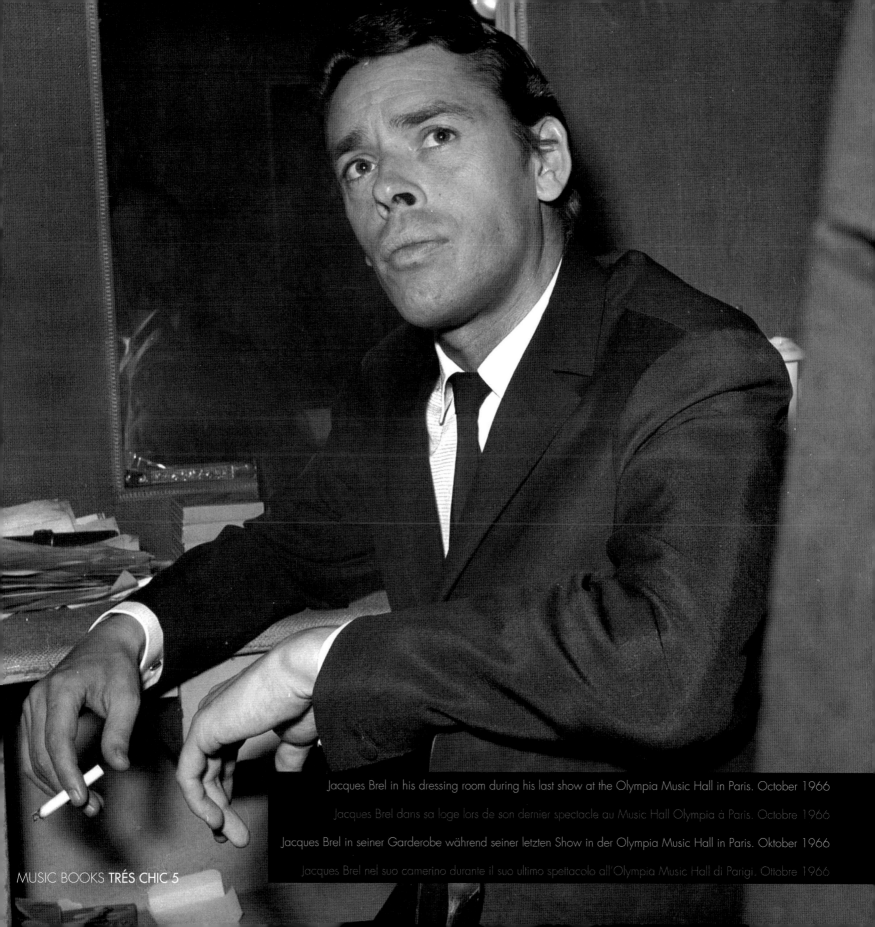

Jacques Brel in his dressing room during his last show at the Olympia Music Hall in Paris. October 1966

Jacques Brel dans sa loge lors de son dernier spectacle au Music Hall Olympia à Paris. Octobre 1966

Jacques Brel in seiner Garderobe während seiner letzten Show in der Olympia Music Hall in Paris. Oktober 1966

Jacques Brel nel suo camerino durante il suo ultimo spettacolo all'Olympia Music Hall di Parigi. Ottobre 1966

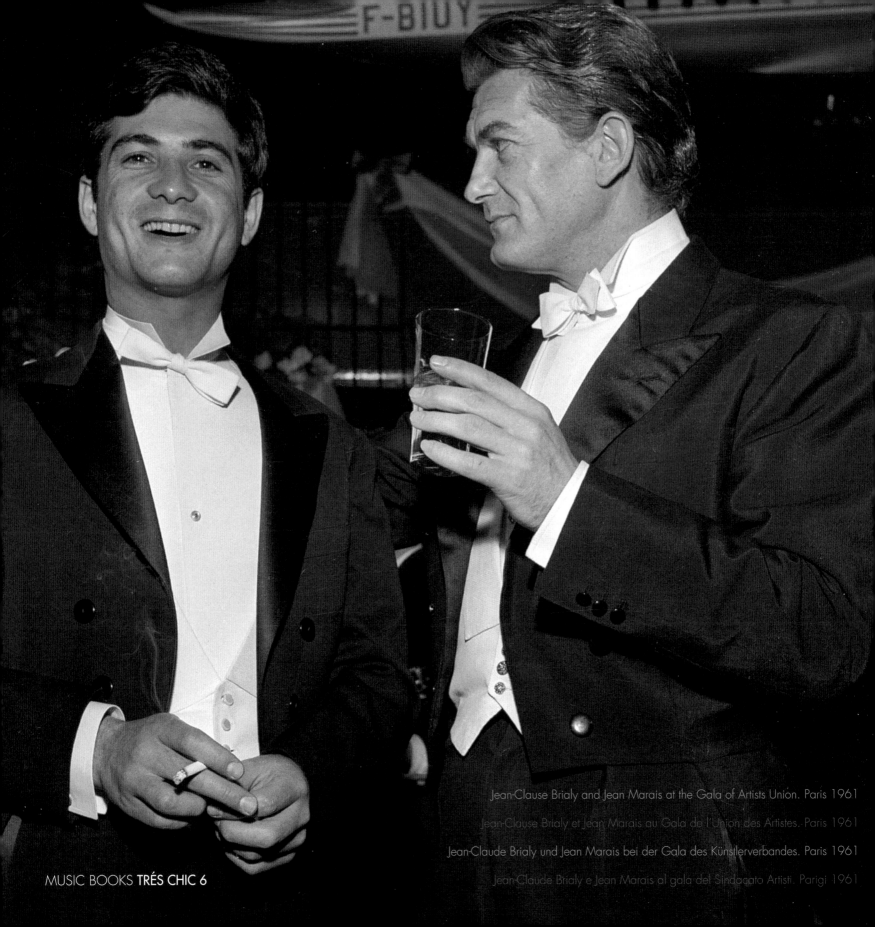

Jean-Clause Brialy and Jean Marais at the Gala of Artists Union. Paris 1961

Jean-Clause Brialy et Jean Marais au Gala de l'Union des Artistes. Paris 1961

Jean-Claude Brialy und Jean Marais bei der Gala des Künstlerverbandes. Paris 1961

Jean-Claude Brialy e Jean Marais al gala del Sindacato Artisti. Parigi 1961

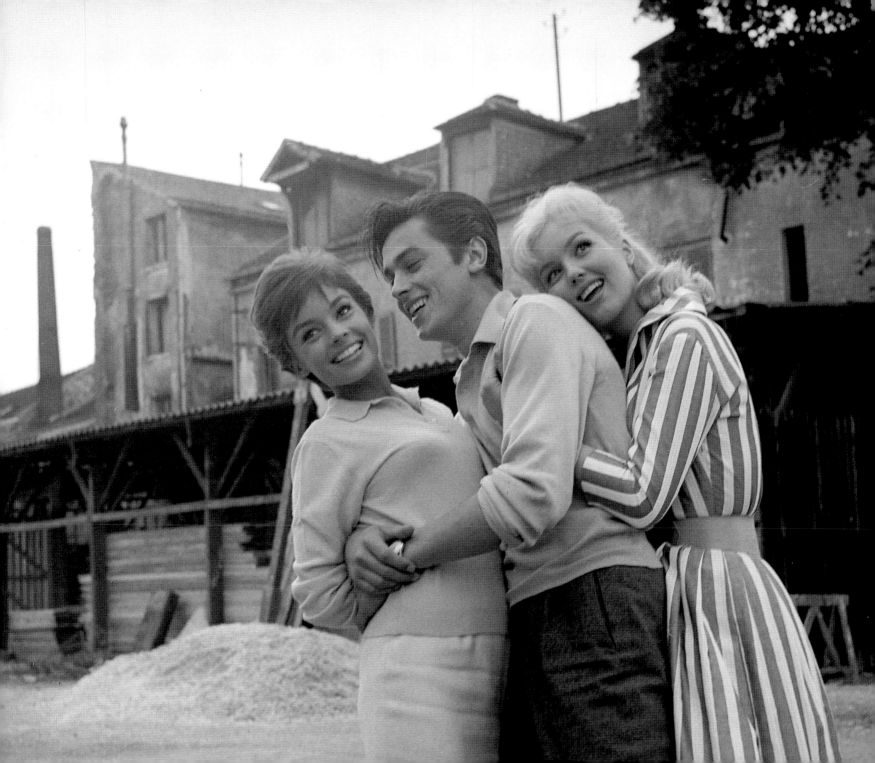

Alain Delon and Bella Darvi boating during the Cannes Film Festival. May 1958

Alain Delon et Bella Darvi en bateau pendant le Festival de Cannes. Mai 1958

Alain Delon und Bella Darvi Bootfahren während der Filmfestspiele von Cannes. Mai 1958

Alain Delon e Bella Darvi in barca durante il Festival di Cannes. Maggio 1958

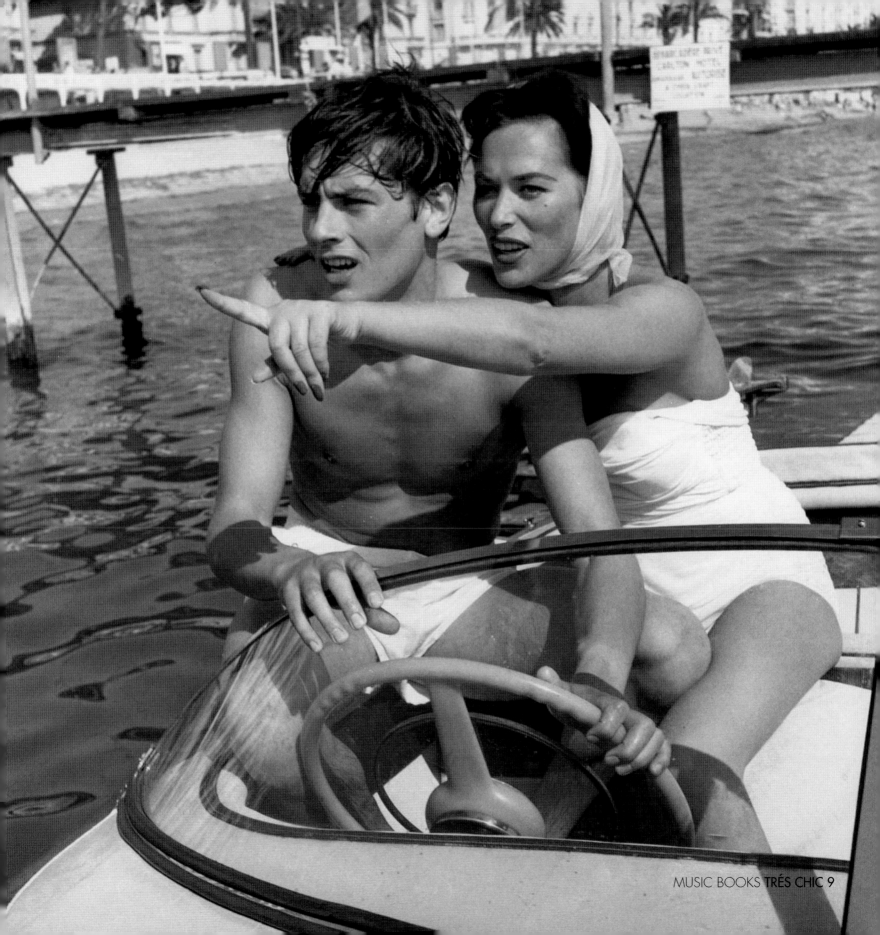

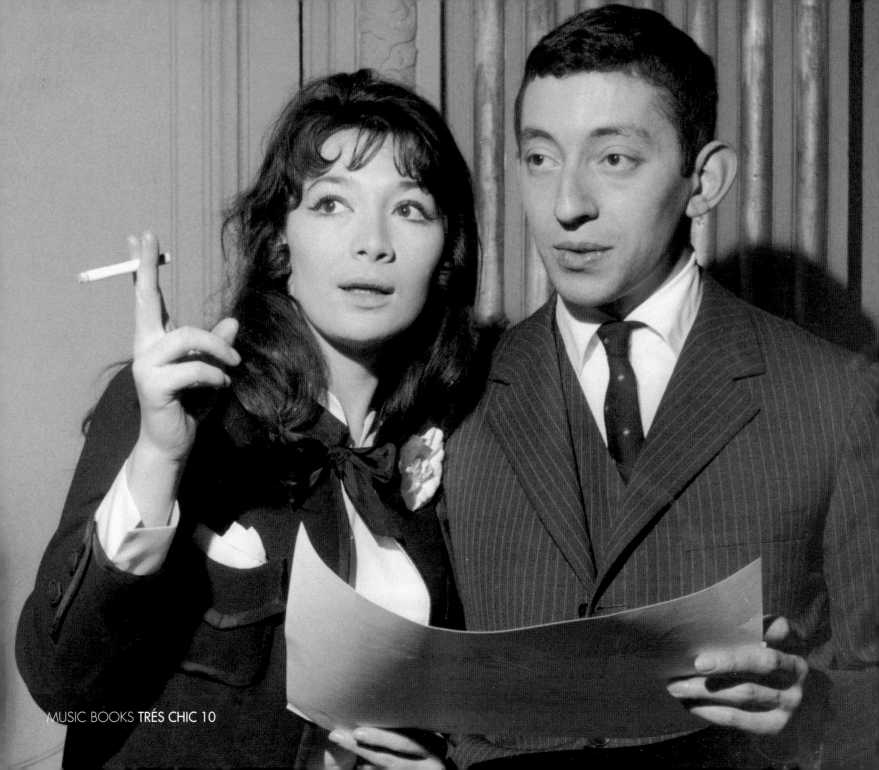

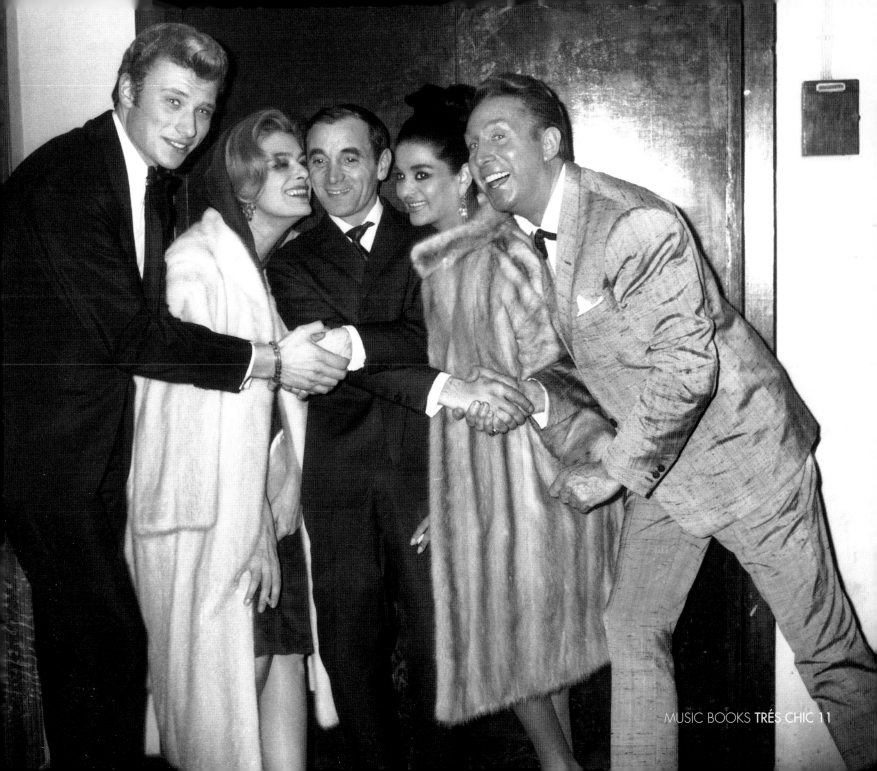

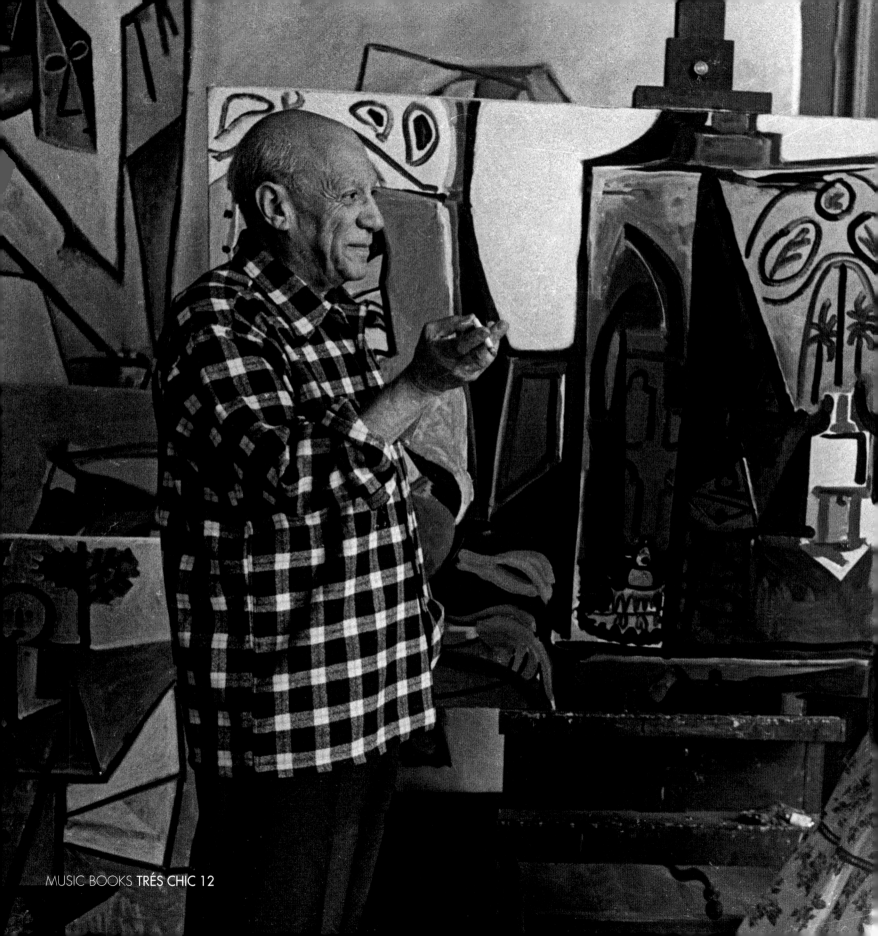

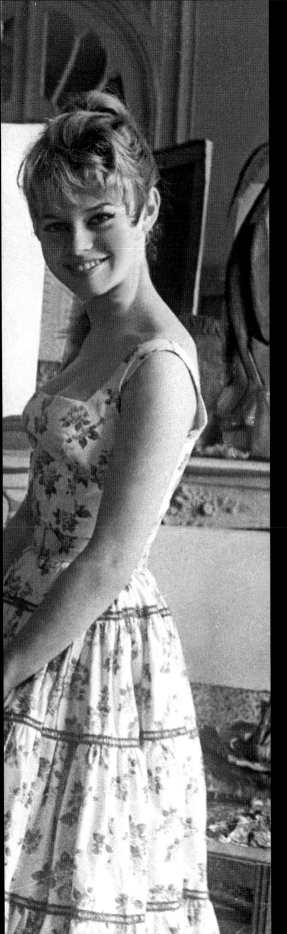

Brigitte Bardot with Pablo Picasso at his studio in Vallauris on the Côte d'Azur. April 1956

Brigitte Bardot avec Pablo Picasso dans son atelier à Vallauris sur la Côte d'Azur. Avril 1956

Brigitte Bardot mit Pablo Picasso in seinem studio in Vallauris an der Côte d'Azur. April 1956

Brigitte Bardot con Pablo Picasso nel suo studio a Vallauris in Costa Azzurra. Aprile 1956

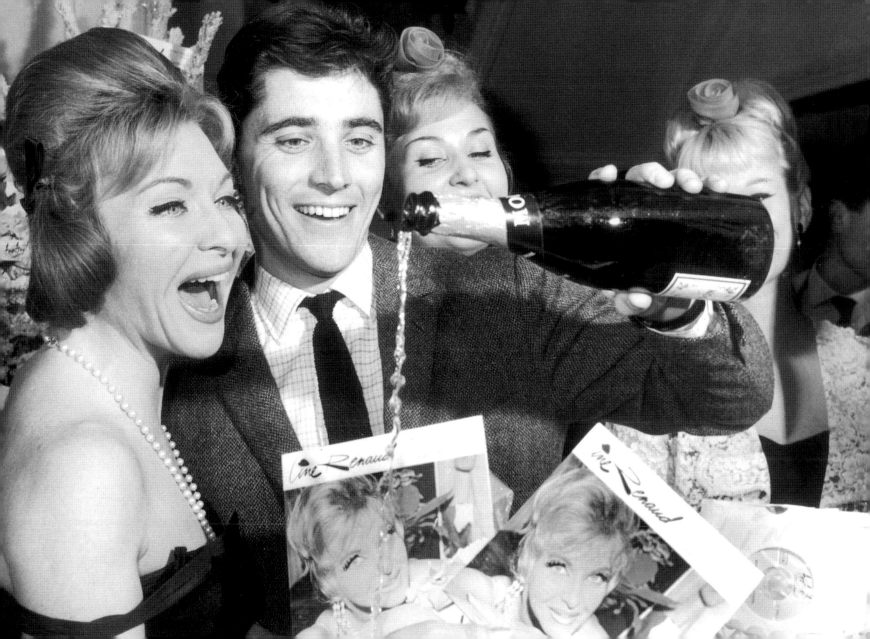

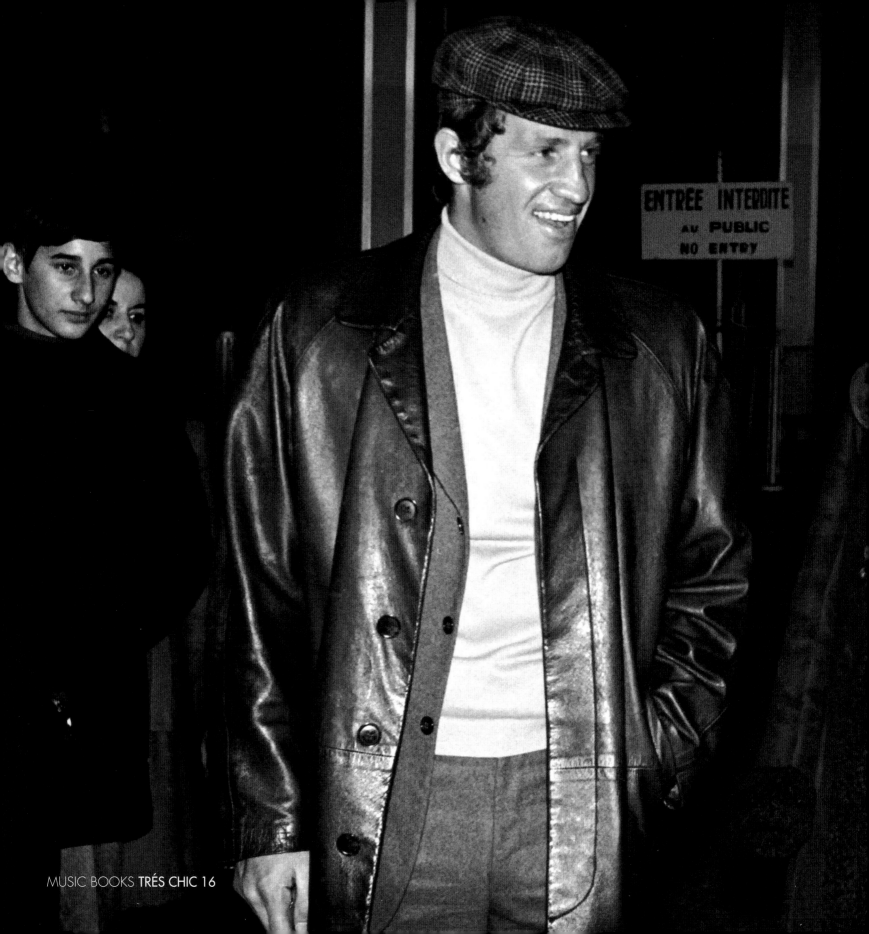

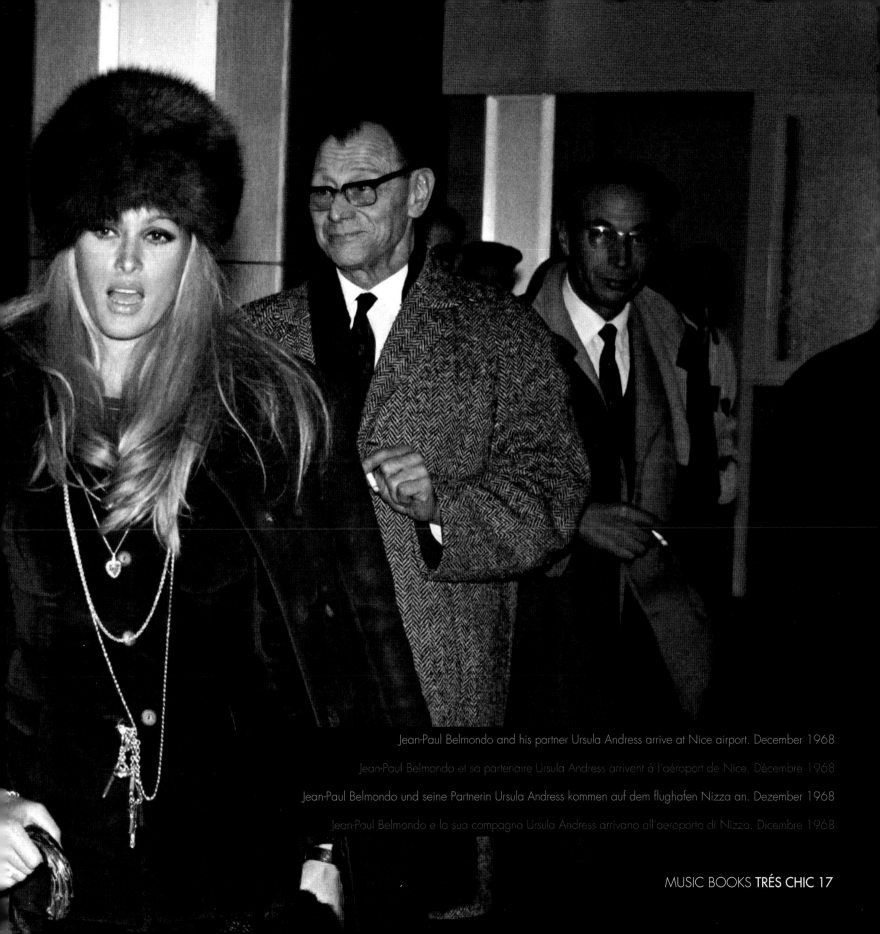

Jean-Paul Belmondo and his partner Ursula Andress arrive at Nice airport. December 1968

Jean-Paul Belmondo et sa partenaire Ursula Andress arrivent à l'aéroport de Nice. Décembre 1968

Jean-Paul Belmondo und seine Partnerin Ursula Andress kommen auf dem flughafen Nizza an. Dezember 1968

Jean-Paul Belmondo e la sua compagna Ursula Andress arrivano all'aeroporto di Nizza. Dicembre 1968

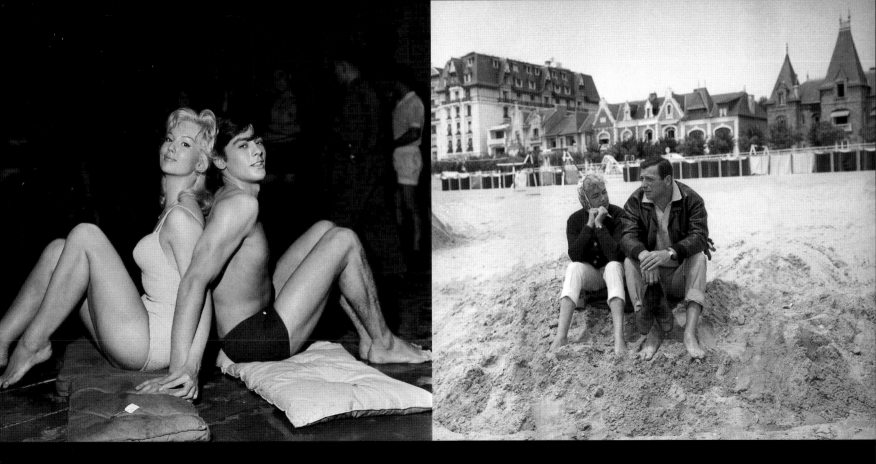

Yves Montand and Simone Signoret on the beach at La Baule. France 1959

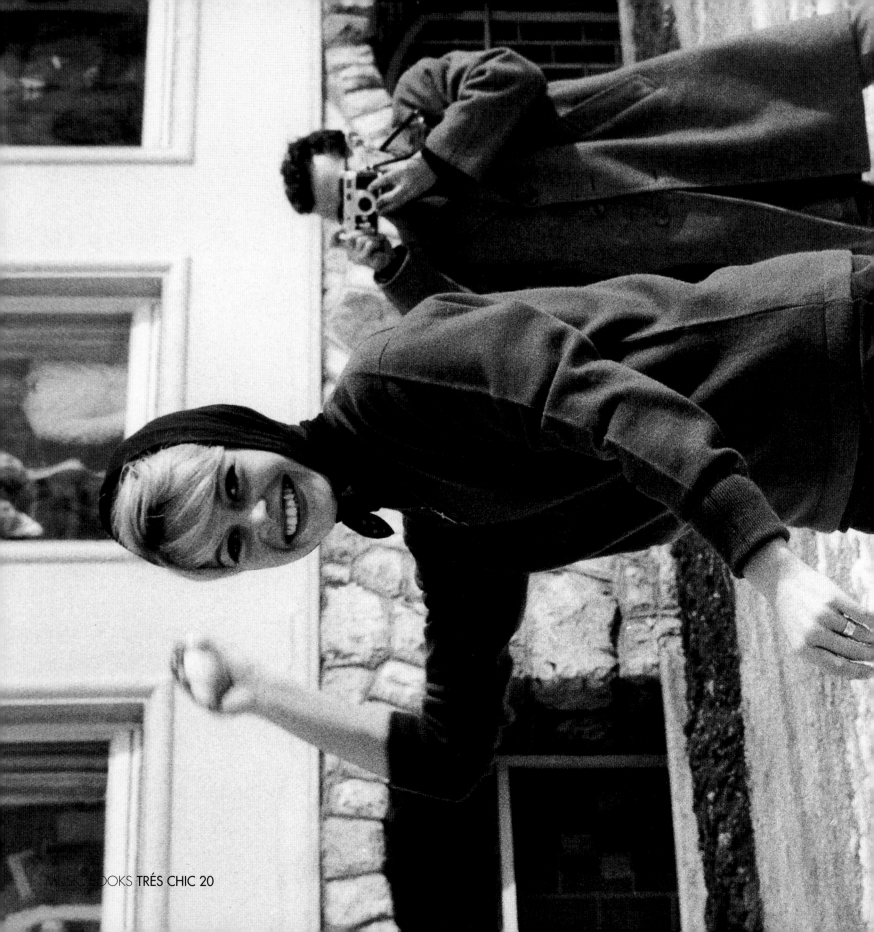

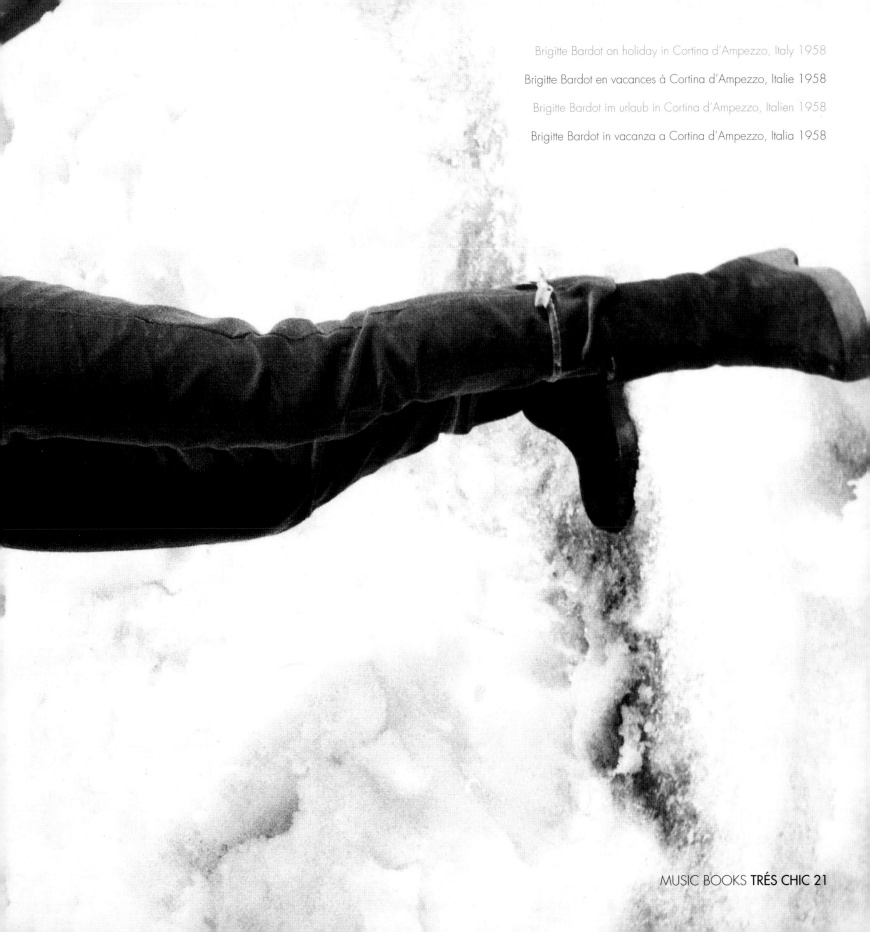

Brigitte Bardot on holiday in Cortina d'Ampezzo, Italy 1958

Brigitte Bardot en vacances à Cortina d'Ampezzo, Italie 1958

Brigitte Bardot im urlaub in Cortina d'Ampezzo, Italien 1958

Brigitte Bardot in vacanza a Cortina d'Ampezzo, Italia 1958

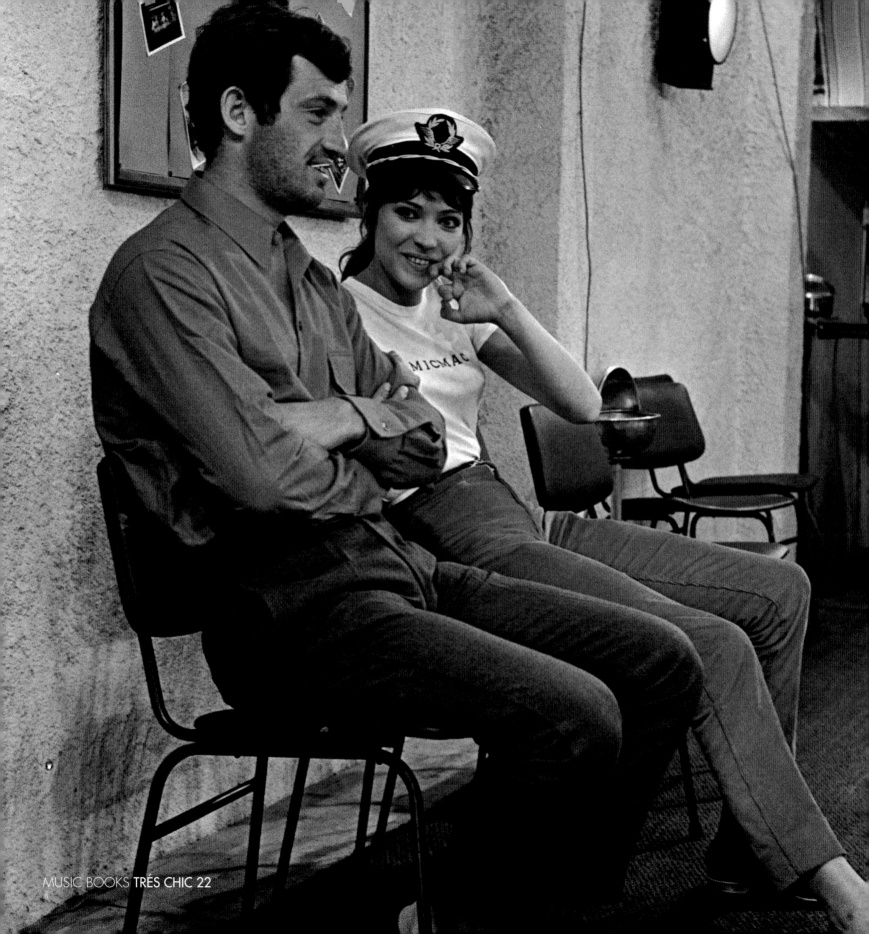

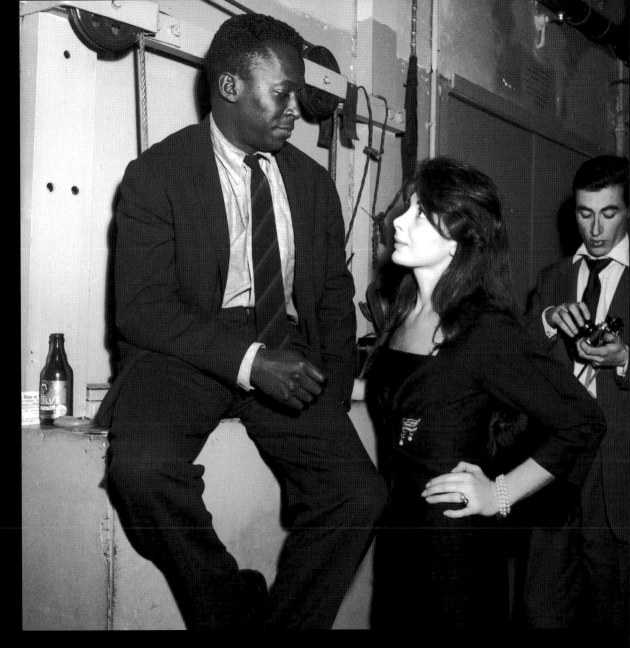

Jean-Paul Belmondo and Anna Karina on the movie set of 'Pierrot Le Fou'.
France, June 1965

Jean-Paul Belmondo et Anna Karina sur le plateau de tournage de "Pierrot Le Fou".
France, Juin 1965

Jean-Paul Belmondo und Anna Karina am filmset von "Pierrot Le Fou".
Frankreich, Juni 1965

Jean-Paul Belmondo e Anna Karina sul set cinematografico di 'Pierrot Le Fou'.
Francia, Giugno 1965

Juliette Gréco and Miles Davis at the club Saint Germain In Paris, France 1958

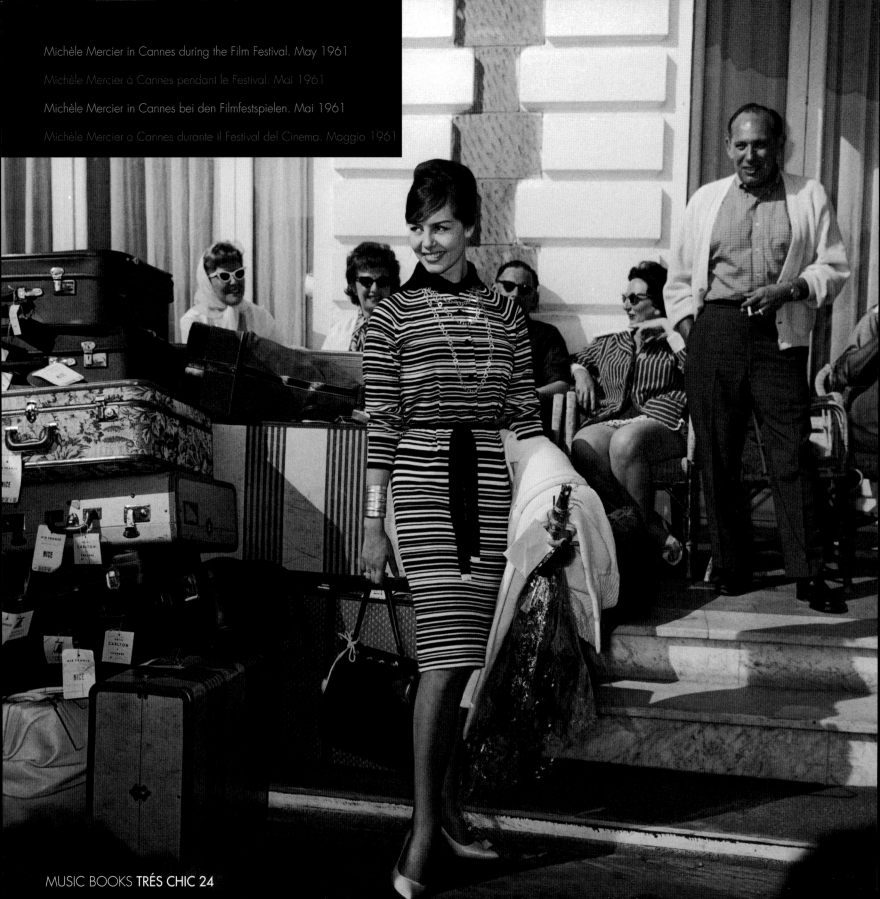

Claudia Cardinale at Cannes Film Festival 1961

Claudia Cardinale au Festival de Cannes 1961

Claudia Cardinale in Cannes Film Festival 1961

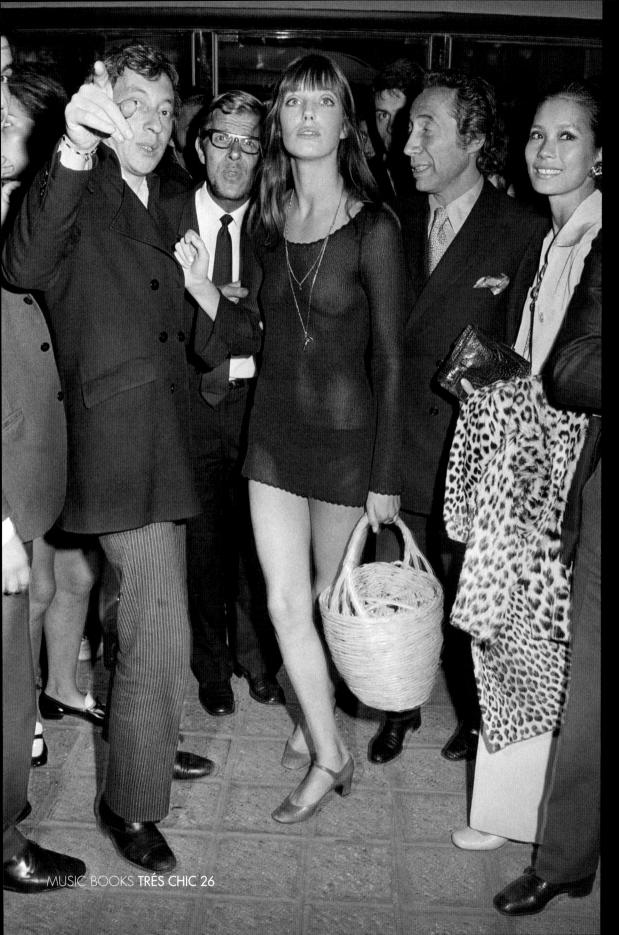

Serge Gainsourg, Jane Birkin and
Pierre Grimblat at the premiere of 'Slogan' l
Pierre Grimblat. Paris 1969

Serge Gainsbourg, Jane Birkin et
Pierre Grimblat à la première de 'Slogan' d
Pierre Grimblat. Paris 1969

Serge Gainsbourg, Jane Birkin und
Pierre Grimblat bei der premiere von 'Sloga
durch Pierre Grimblat. Paris 1969

Serge Gainsbourg, Jane Birkin e
Pierre Grimblat alla premiere di 'Slogan' di
Pierre Grimblat. Parigi 1969

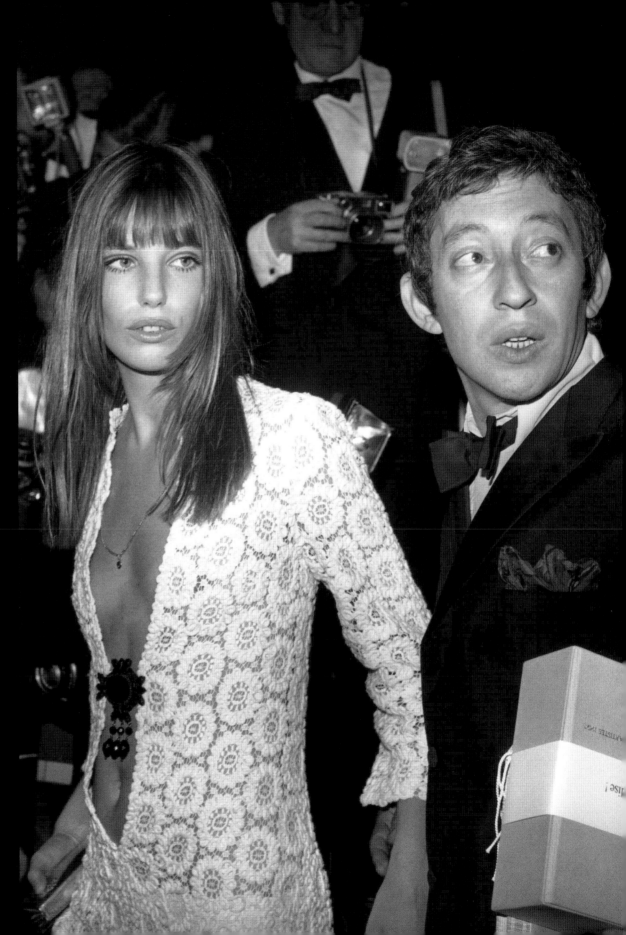

Serge Gainsbourg and Jane Birkin arriving at the
Gala of Artists Union, Paris 1969

Serge Gainsbourg et Jane Birkin arrivent au
Gala de l'Union des Artistes. Paris 1969

Serge Gainsbourg und Jane Birkin kommen zur
Gala der Künstler Union, Paris 1969

Serge Gainsbourg e Jane Birkin arrivano presso
il gala del Sindacato artisti, Parigi 1969

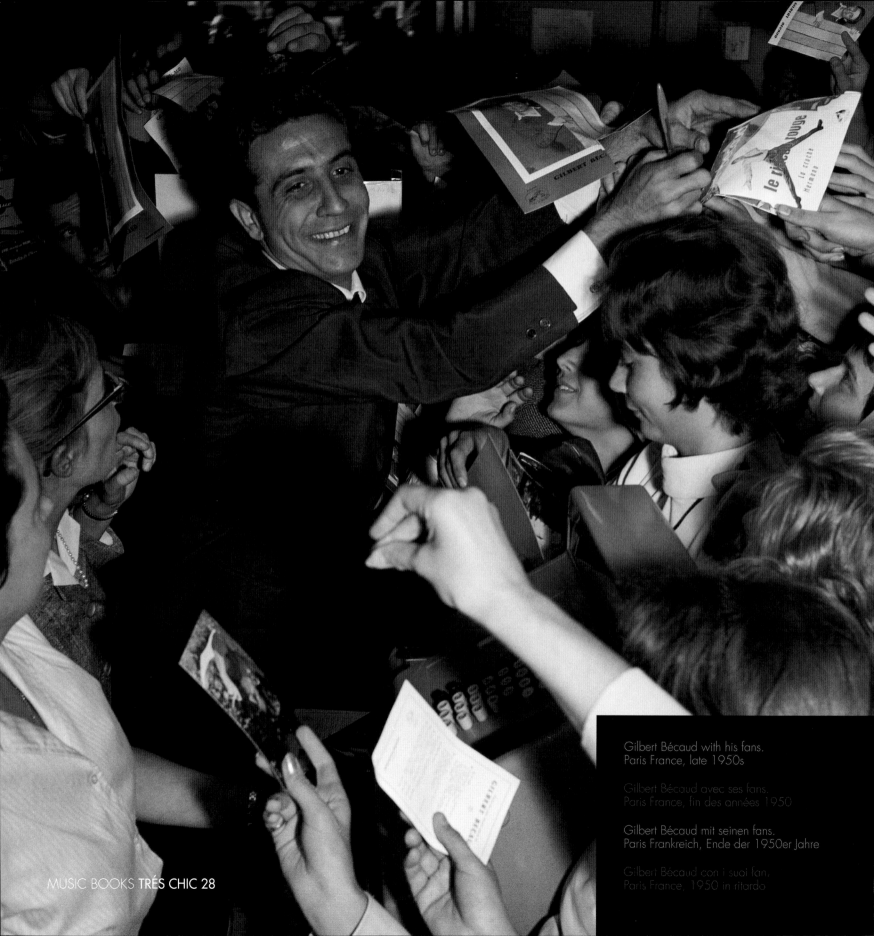

Gilbert Bécaud with his fans.
Paris France, late 1950s

Gilbert Bécaud avec ses fans.
Paris France, fin des années 1950

Gilbert Bécaud mit seinen fans.
Paris Frankreich, Ende der 1950er Jahre

Gilbert Bécaud con i suoi fan,
Paris France, 1950 in ritardo

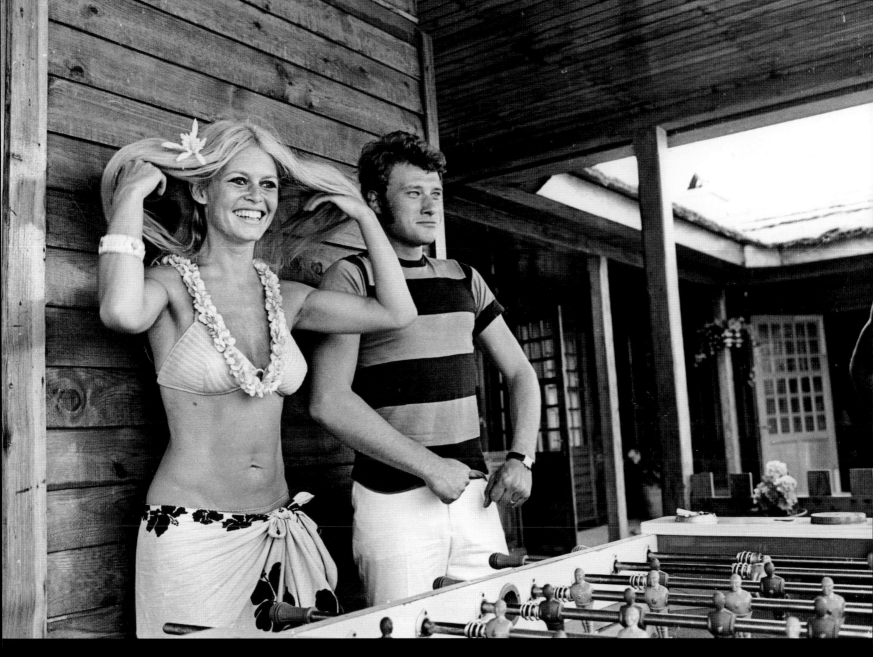

Johnny Hallyday and Brigitte Bardot in Saint Tropez, France. August 1967

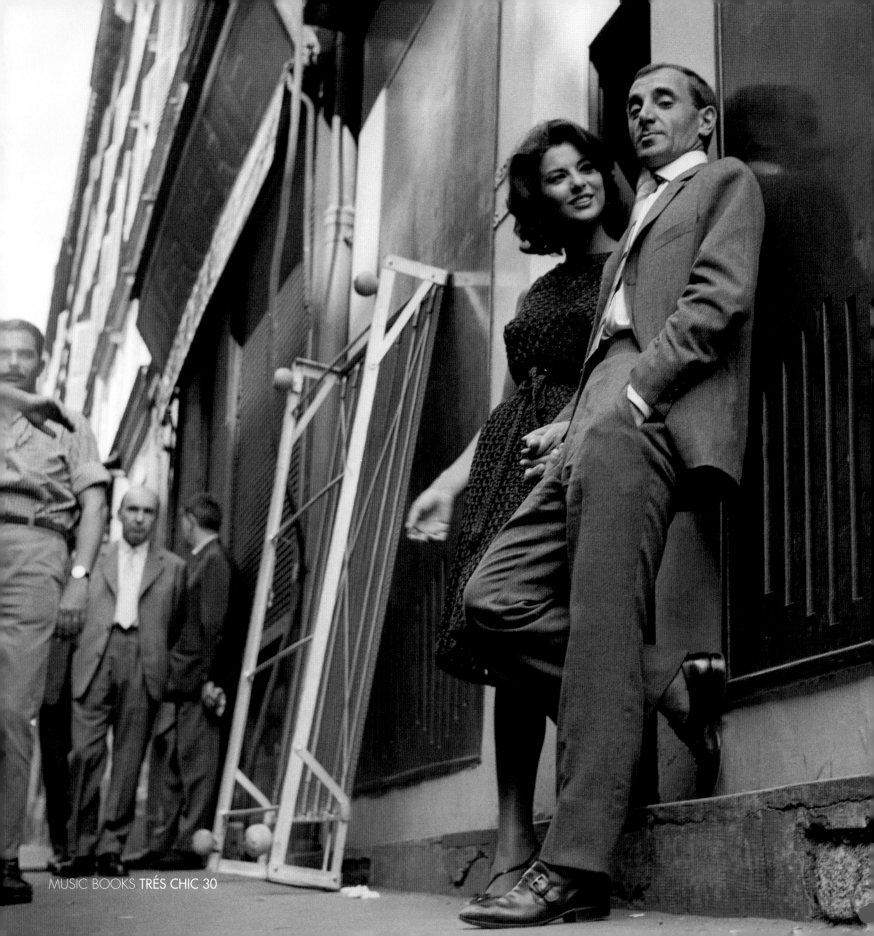

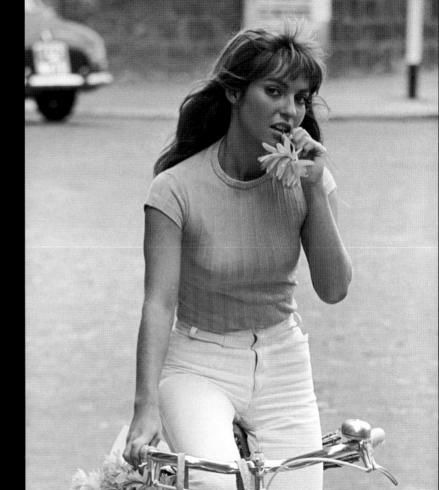

Marie-France Pisier cycling in Paris, August 1967

Marie-France Pisier vélo à Paris, Août 1967

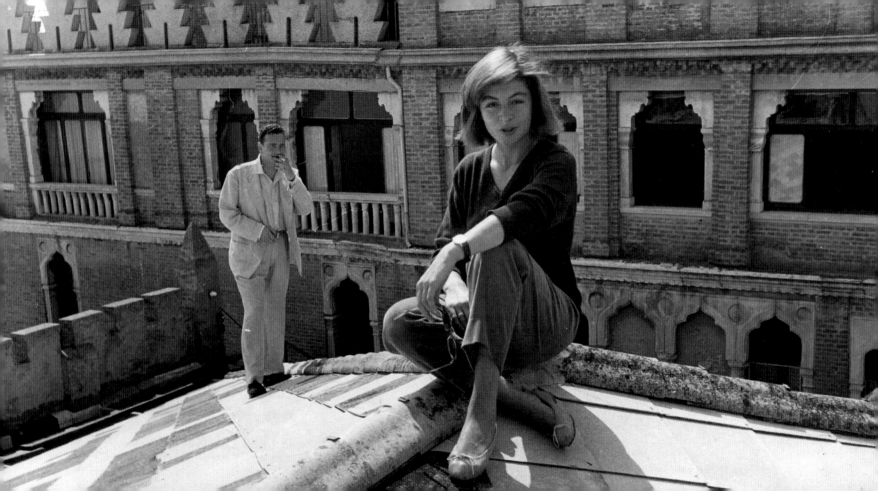

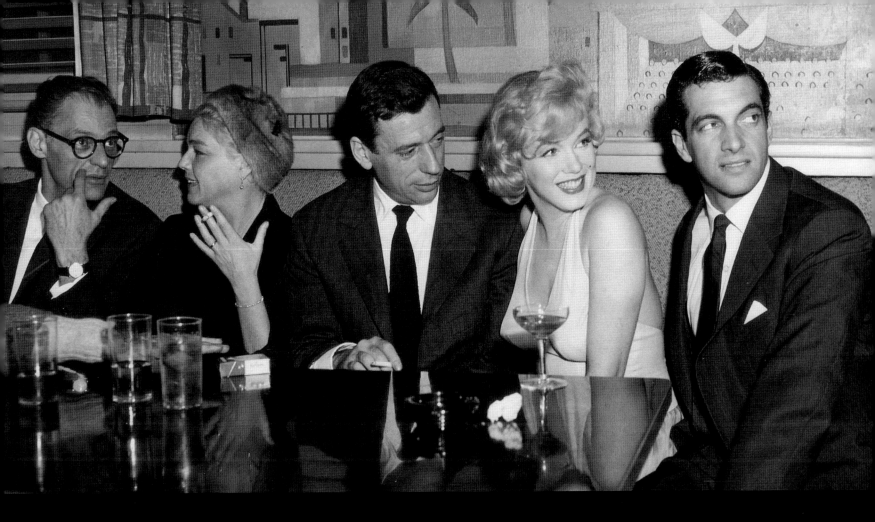

Arthur Miller, Simone Signoret, Yves Montand, Marilyn Monroe and Frankie Vaughan, at a cafe table. 1960

Arthur Miller, Simone Signoret, Yves Montand, Marilyn Monroe et Frankie Vaughan, à une table de café. 1960

Arthur Miller, Simone Signoret, Yves Montand, Marilyn Monroe und Frankie Vaughan, an einem café-tisch. 1960

Arthur Miller, Simone Signoret, Yves Montand, Marilyn Monroe e Frankie Vaughan, al tavolino di un caffè. 1960

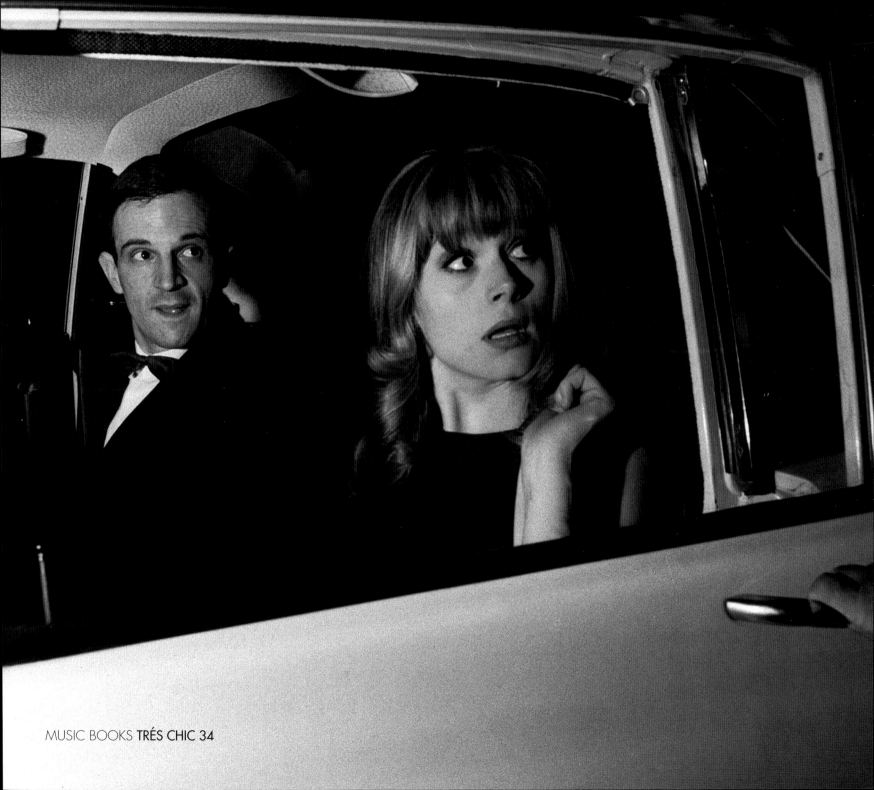

MUSIC BOOKS **TRÉS CHIC 34**

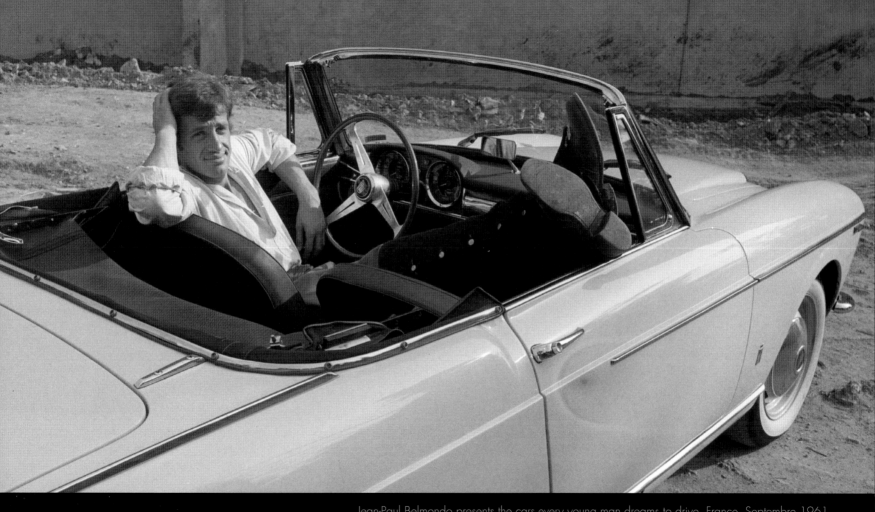

Jean-Paul Belmondo presents the cars every young man dreams to drive. France, Septembre 1961

Jean-Paul Belmondo présente les voitures que chaque jeune homme rêve de conduire. France, Septembre 1961

Jean-Paul Belmondo stellt die autos, von denen jeder junge mann träumt, vor. Frankreich, Septembre 1961

Brigitte Bardot surrounded by the Navy.
France, Côte d'Azur, August 1958

Brigitte Bardot entourée par la Marine.
France, Côte d'Azur, Août 1958

Brigitte Bardot, umgeben von der Marine.
Frankreich, Côte d'Azur, August 1958

Brigitte Bardot circondata dalla Marina.
Francia, Côte d'Azur, Agosto 1958

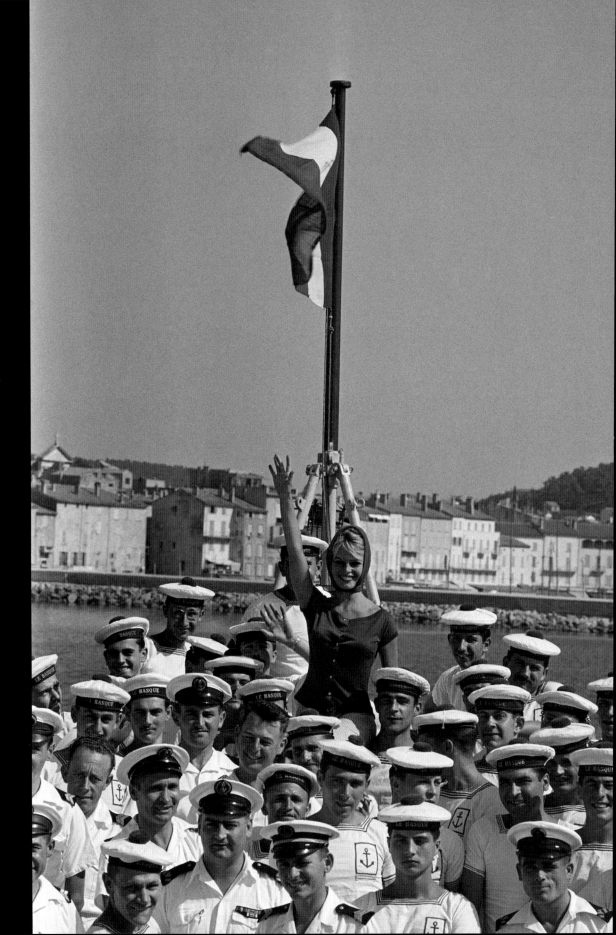

Dalida on holiday. June 1965

Dalida en vacances. Juin 1965

Dalida im urlaub. Juni 1965

Dalida in vacanza. Giugno 1965

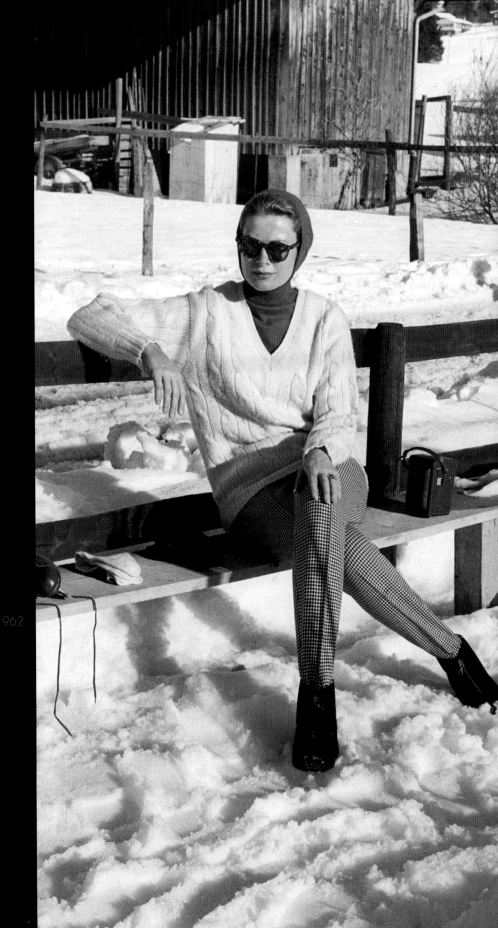

Princess Grace of Monaco on holiday in St Moritz. February 1962

Princesse Grace de Monaco en vacances à St Moritz. Février 1962

Princesse Grace de Monaco im urlaub in St. Moritz. Februar 1962

La Principessa Grace di Monaco in vacanza a St Moritz. Febbraio 1962

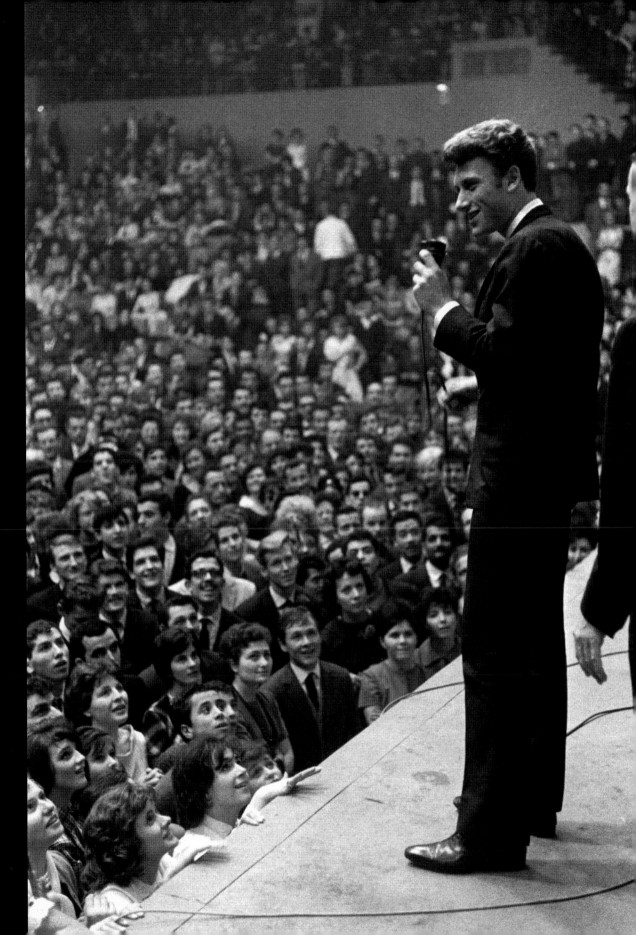

Johnny Hallyday at the Bal des Catherinettes
in France. November 1961

Johnny Hallyday au Bal des Catherinettes en
France. Novembre 1961

Johnny Hallyday in den Bal des Catherinettes
in Frankreich. November 1961

Johnny Hallyday al Bal des Catherinettes in
Francia. Novembre 1961

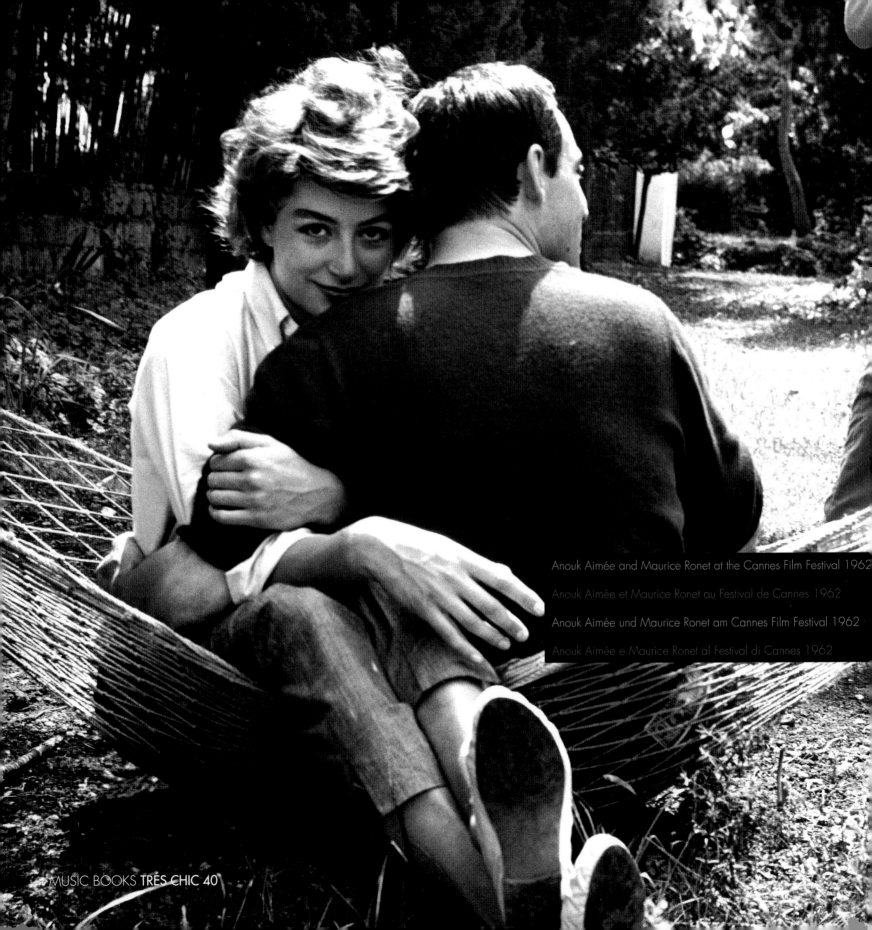

Anouk Aimée and Maurice Ronet at the Cannes Film Festival 1962

Anouk Aimée et Maurice Ronet au Festival de Cannes 1962

Anouk Aimée und Maurice Ronet am Cannes Film Festival 1962

Anouk Aimée e Maurice Ronet al Festival di Cannes 1962

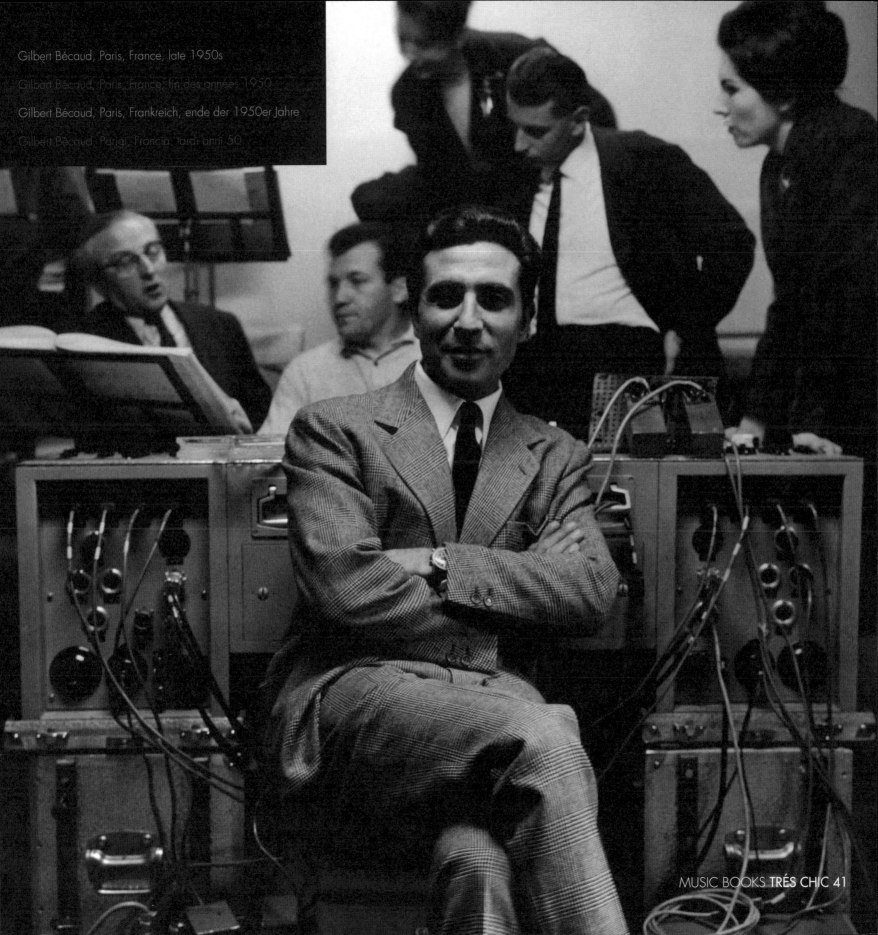

CD1

1. **Brigitte Bardot** Le Soleil
(Riviere/Bourgeois) Warner Chappell Overseas Holdings Ltd.

2. **Charles Aznavour** Je M'voyais Déjà
(Aznavour) Catalyst Music Publishing Ltd.

3. **Sacha Distel** Brigitte
(Broussolle/Distel) Copyright Control

4. **Françoise Hardy** Le Temps De L'amour
(Lucien Jean Morisse/Andre Michel Charles Salvet/Jacques Dutronc) Alpha Music Publishing UK Ltd.

5. **Annie Cordy** Cigarettes, Whisky Et Petites Pepees
(Llenas/Spencer/Soumet) Copyright Control

6. **Johnny Hallyday** Souvenirs, Souvenirs
(Finet/Coben/Bonifay) Bourne Music Ltd.

7. **Boris Vian** Je Suis Snob
(Walter/Vian) Peermusic (UK) Ltd.

8. **Jacqueline Danno** Chanson De Lola
(Varda/Legrand) Copyright Control

9. **Juliette Gréco** Je Suis Comme Je Suis
(Prevert/Kosma) Enoch and Cie/United Music Publishers Ltd.

10. **Serge Gainsbourg** Requiem Pour Un Twister
(Gainsbourg) Imagem Music/Warner Chappell Overseas Holdings Ltd.

11. **Jacques Brel** La Valse À Mille Temps
(Shuman/Blau/Brel) Merit Music Co Ltd.

12. **Magali Noël** Fais Moi Mal Johnny
(Vian/Goraguer) Warner Chappell Overseas Holdings Ltd.

13. **Yves Montand** Les Grands Boulevards
(Norbert Glanzberg/Jacques Plante) Universal/MCA Music Ltd.

14. **The Modern Jazz Quartet** Versailles (Porte De Versailles)
(Lewis) Kensington Music Ltd.

15. **Zizi Jeanmaire** La Croqueuse De Diamants
(Queneau/Petit/Damase) Peermusic (UK) Ltd.

16. **Line Renaud** Sexe
(Gaste) Cabaret De Paris Editions Louis Gaste

17. **Dalida** Bambino
(Salerno/Fucilli/Ageron) Accordo Edizioni Musicali S R L

18. **Félix Leclerc** Moi, Mes Souliers
(LeClerc) Catalyst Music Publ Ltd.

19. **Georges Brassens** Je Me Suis Fait Tout Petit
(Brassens) Warner Chappell Overseas Holdings Ltd.

20. **Mercenaires** Quand Tu T'y Mets
(Gainsbourg) Warner Chappell Overseas Holdings Ltd.

CD2

1. **Serge Gainsbourg** Intoxicated Man
(Gainsbourg) Imagem Music/Warner Chappell Overseas Holdings Ltd.

2. **Claude Nougaro** Maman Me L'a Dit
(Walter/Nougaro) Campbell Connelly And Co Ltd./Benjamin Lazare Walter/Claude Nougaro

3. **Gilbert Bécaud** Viens
(Becaud/Aznavour) Metisse Music (UK) Ltd./Catalyst Music Publ Ltd.

4. **Barbara** La Belle Amour
(Charles Algarra/Georges Emile Berard/Barbara) Catalyst Music Publ Ltd.

5. **Mick Micheyl** Un Gamin De Paris
(Micheyl/Mares) Catalyst Music Publ Ltd./Metropolitaines Editions/Francis Day And Hunter Ltd.

6. **Henri Salvador** Amour De Saint Tropez
(Maheux) Warner Chappell Overseas Holdings Ltd.

7. **Brigitte Bardot** Sidonie
(Robert Mellin/Yano Spanos/Charles Hortensius Emile Cros) EMI Music Publishing Ltd.

8. **Léo Ferré** T'es Chouette
(Ferre) Copyright Control

9. **Les Double Six** Moanin'
(Timmons) Bucks Music Group Ltd.

10. **Catherine Sauvage** La Fille De Londres
(Enoch/Verschueren/Dumarchey) Enoch And Cie

11. **Jacques Brel** Ne Me Quitte Pas
(Brel) Warner Chappell Overseas Holdings Ltd.

12. **Sacha Distel** Scoubidou
(Tézé/Distel) Peter Maurice Music Co Ltd.

13. **Johnny Hallyday** 24,000 Baisers
(De Paulis/Vivarelli/Celentano/Fulci) Ear Ed Mus Edit Aut Riuniti S A S

14. **Michel Legrand** Blues Chez Le Bougnat
(Legrand) Warner Chappell Overseas Holdings Ltd.

15. **Patachou** La Bague A Jules
(Siniavine/Blanvillain) Peermusic (UK) Ltd.

16. **Yves Montand** C'est Si Bon
(Betti/Hornez/Seelen) Peter Maurice Music Co Ltd.

17. **Renée Lebas** La Valse Des Lilas
(Barclay/Legrand/Marney) Barclay Eddie Editions/Universal/MCA Music Ltd.

18. **Juliette Gréco** Si Tu T' Imagines
(Queneau/Kosma) Enoch And Cie/United Music Publishers Ltd.

19. **Mouloudji** Comme Un P'tit Coquelicot
(Valery/Asso) Peermusic (UK) Ltd.

20. **Martial Solal** Duo
(Solal) Sidomusic B Liechti Et Cie